Suzi:
Thought of you [...]
this — how cer[...]
It seemed [...]
to give it to you during
our 5th visit to Europe
together.

Have a wonderful
Birthday!!
Love,
Arianne

The CATS *of* VENICE

SHIN OTANI

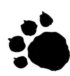

CHRONICLE BOOKS

SAN FRANCISCO

Special thanks to Reiko Otani.

First published in the United States in 1998
by Chronicle Books.

First published in Japan as *Cats in Venice* by Treville Co.,
Ltd., Tokyo, Japan.

Printed in Hong Kong.

ISBN 0-8118-1937-X

Library of Congress Cataloging-in-Publication Data available.

Text and cover design: Patricia Evangelista
Cover photograph: Shin Otani
Translation: Michiko Shigaki and Thomas L.J. Daly

Distributed in Canada by
Raincoast Books
8680 Cambie Street
Vancouver, B.C. V6P 6M9

10 9 8 7 6 5 4 3 2 1

Chronicle Books
85 Second Street
San Francisco, California 94105

Web Site: www.chronbooks.com

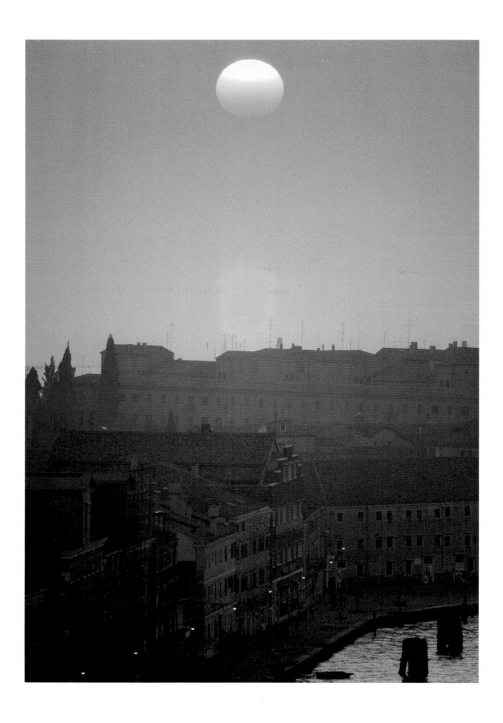

THE CATS OF VENICE

Venice, the city of water, is also a city of cats. In the watery world of gondolas and bridges, cats and people live together comfortably. No cars disturb the peace or threaten the inhabitants.

Crossing the two-and-a-half mile bridge from Mestre on the mainland, you arrive at Piazzale Roma, west of the train station. From this point, you have only two travel choices: to go by boat or on foot. The only vehicles seen in Venice are carts silently rolling across an arched bridge or rumbling down a path between busy streets. Children on bicycles fitted with training wheels unsteadily circle the plazas, as mothers push baby carriages and watch over the bicycling children.

The Venetians are tolerant of cats. In fact, the cats of Venice are cherished, fed, and watched over by people who appreciate the serenity and self-sufficiency of cats. Once, when I was strolling down a passage, the bony remains of a fish suddenly fell from a high window right down next to a cat. This act of serendipity did not surprise me—it was in keeping with the mystery of the city.

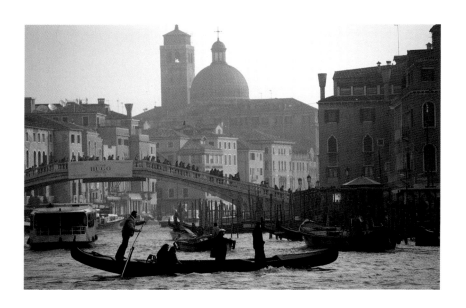

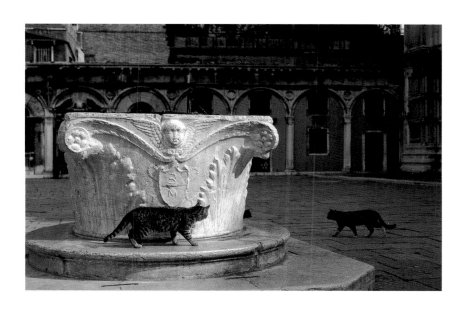

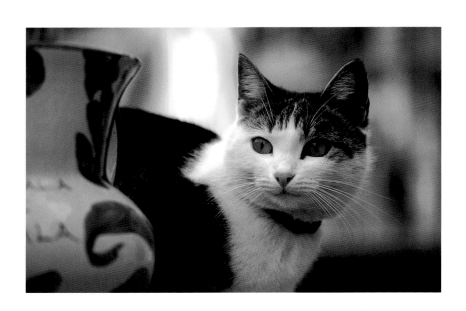

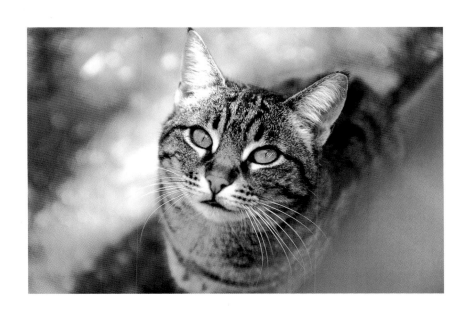

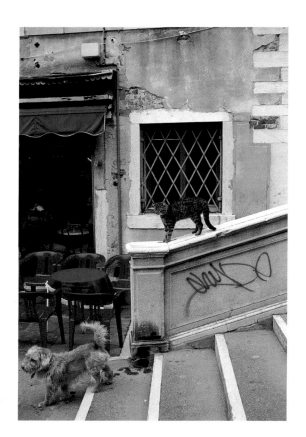

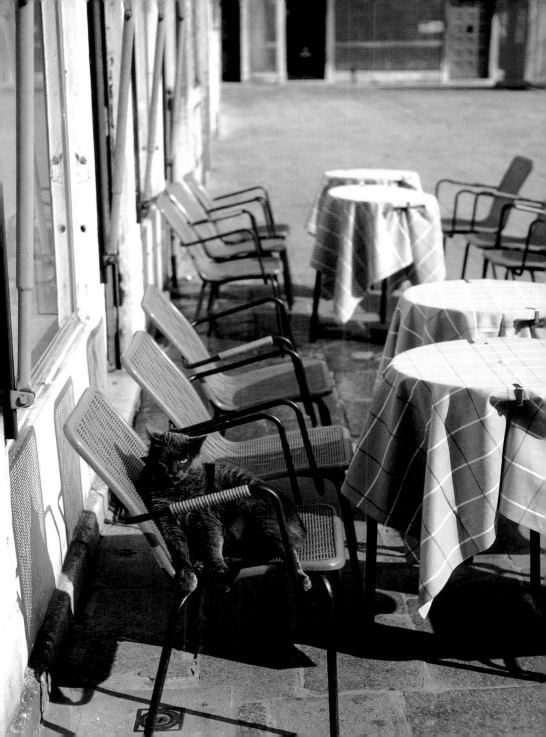

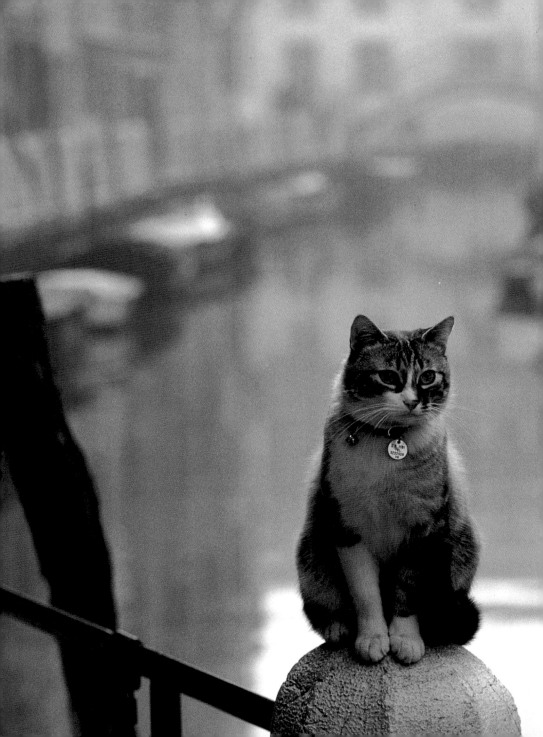

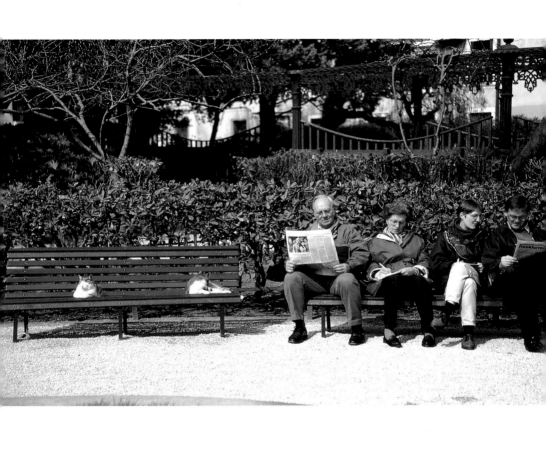

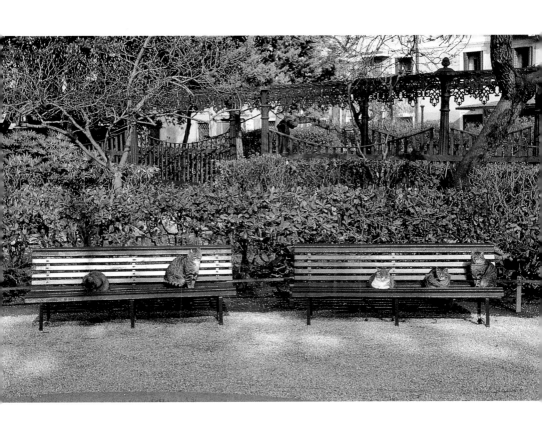

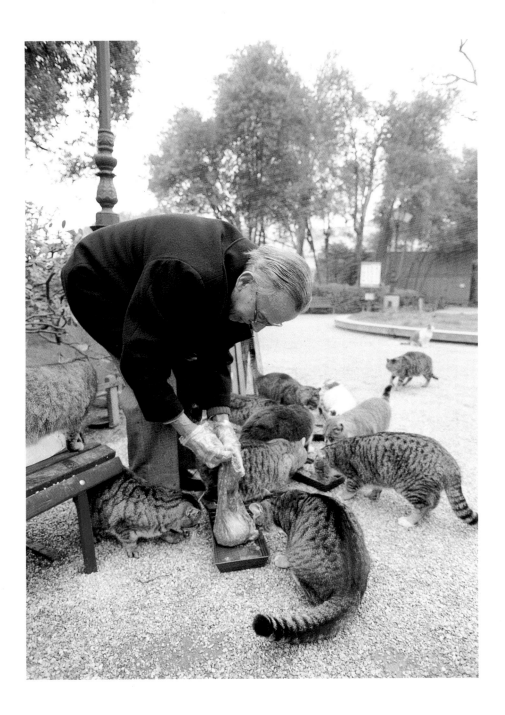

DINGO

Cats have many friends in Venice. A citizen's organization, called DINGO, takes care of stray cats. They feed the cats, provide health care, and supply neutering services. A woman who looked after the cats told me that some of the cats have had an ear tip snipped off, which means that they've undergone a contraceptive procedure. She also said that a British animal protection group used to provide some financial support to DINGO, but that now the Venetians themselves donate money and try to prevent any more unlucky kittens.

Around the town volunteers have constructed cathouses, refuges similar in purpose to the traditional doghouse. These houses come in many forms, from just a pile of boxes with a small entrance to larger structures built of wood. Regardless of their design, each has at its entrance a meal plate, a welcoming sign from the people who care for cats.

The attitude of Venetians, who recognize the stray cats' dignity and right to life and who accept and keep watch over the animals, makes me feel that the idea of coexistence is thriving here in Italy, and above all, in Venice, a town where cat lovers dwell.

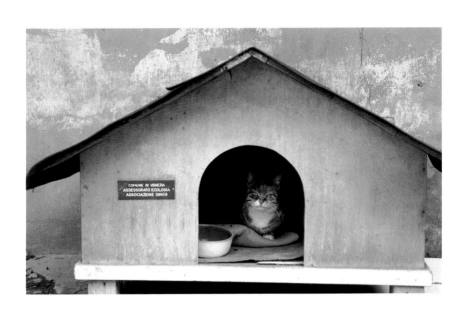

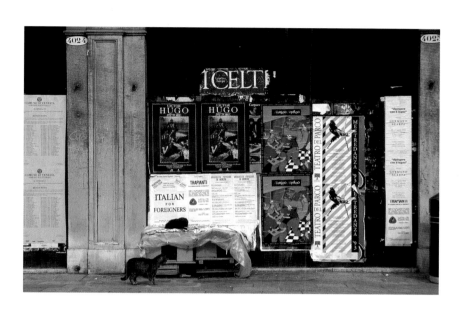

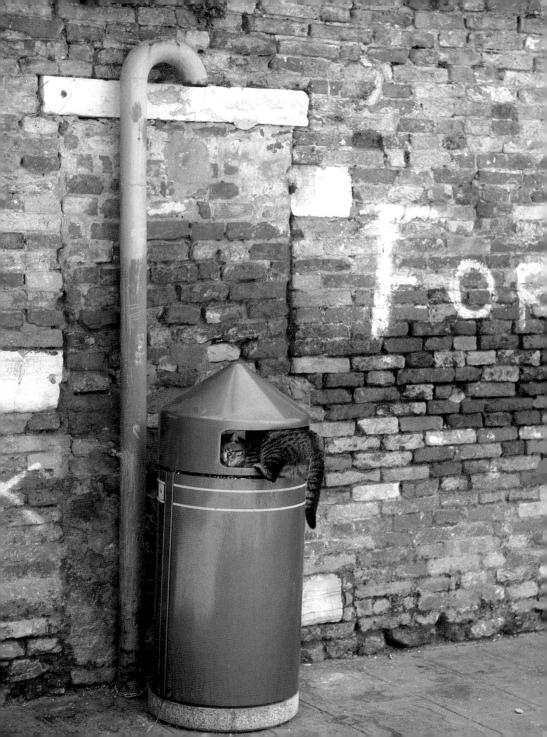

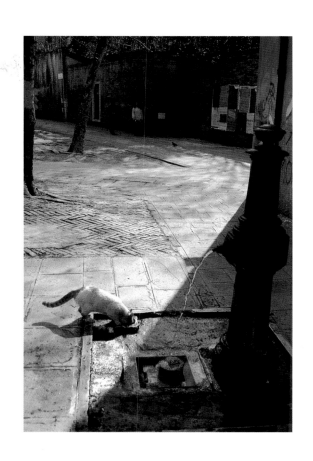

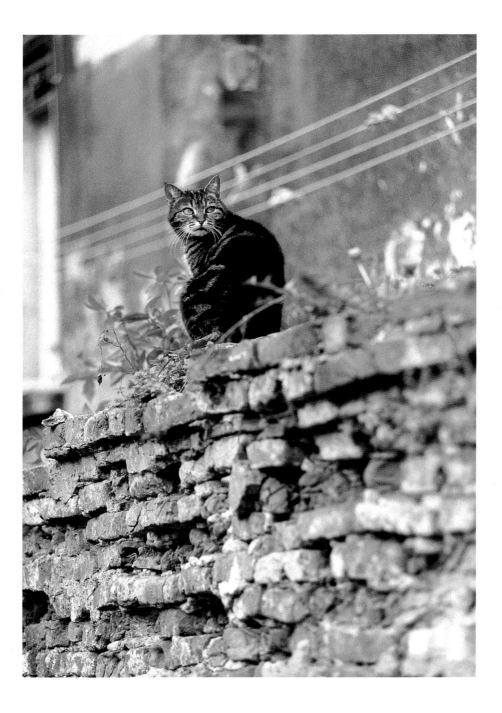

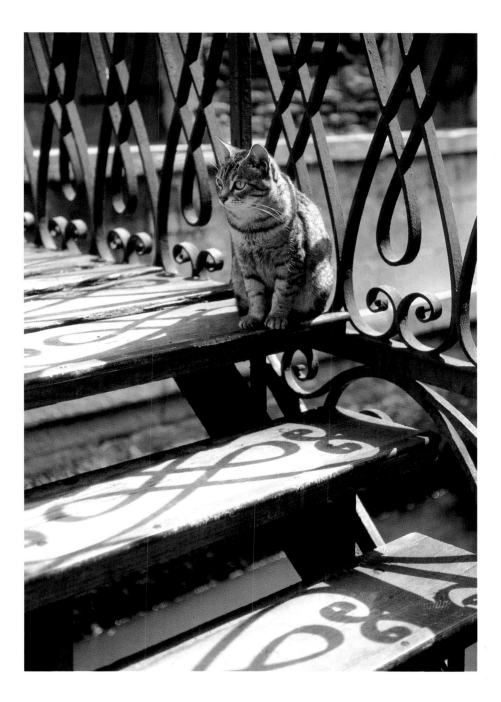

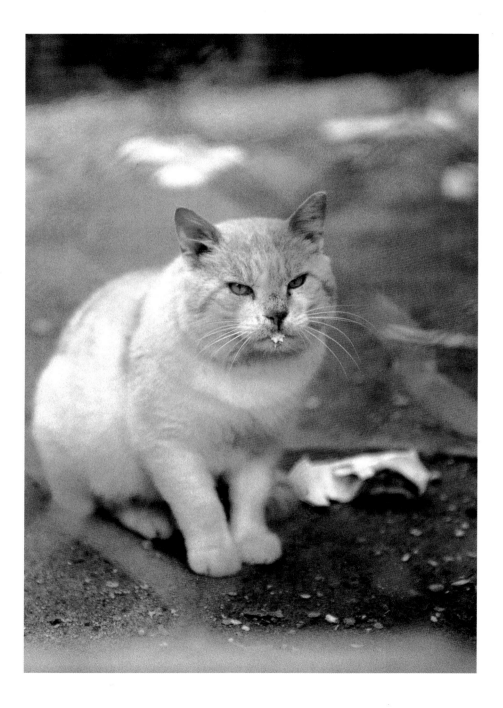

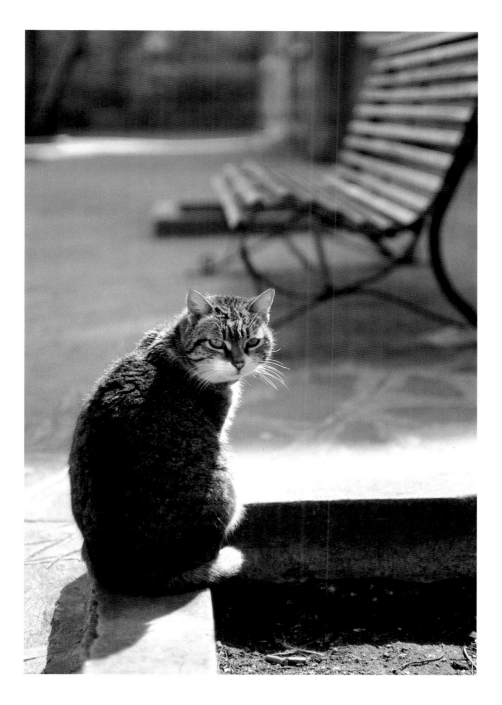

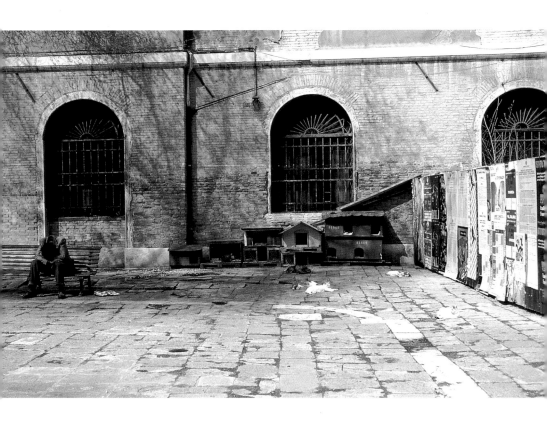

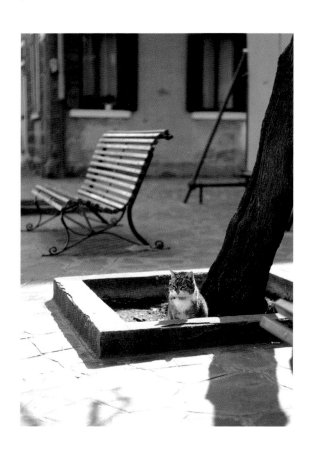

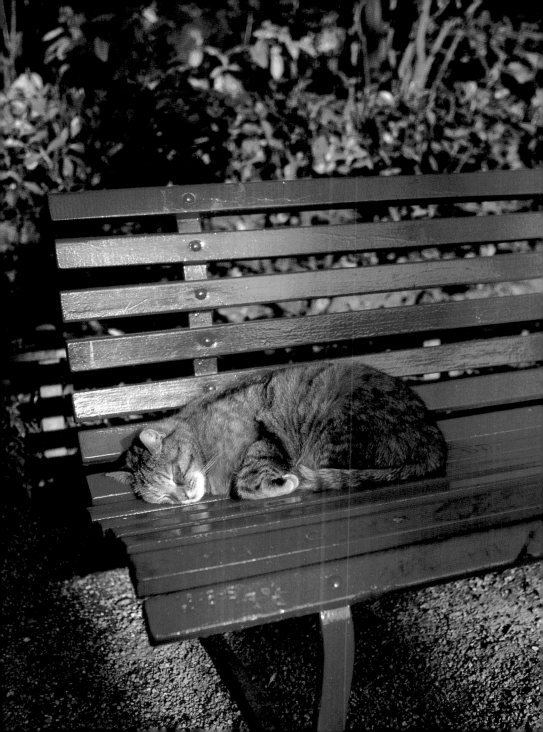

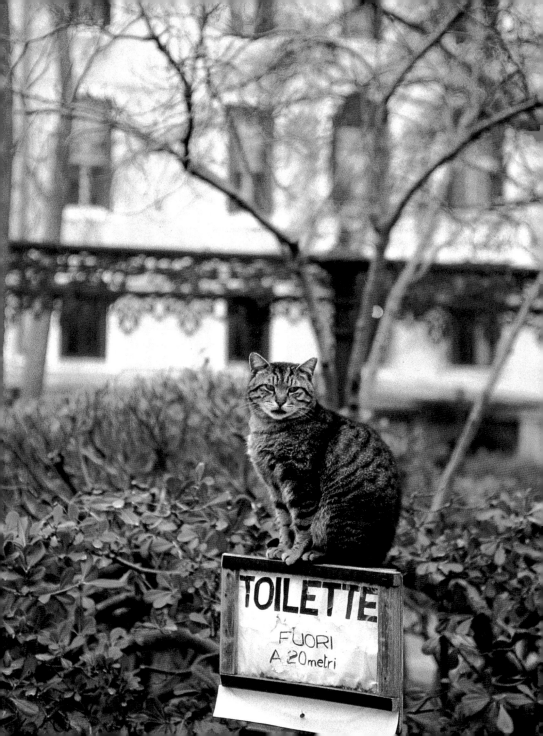

TOILETTE

FUORI
A 20 metri

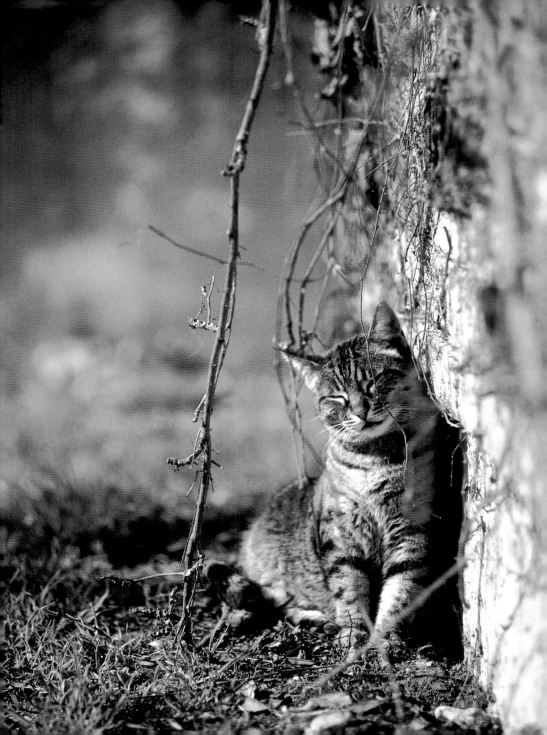

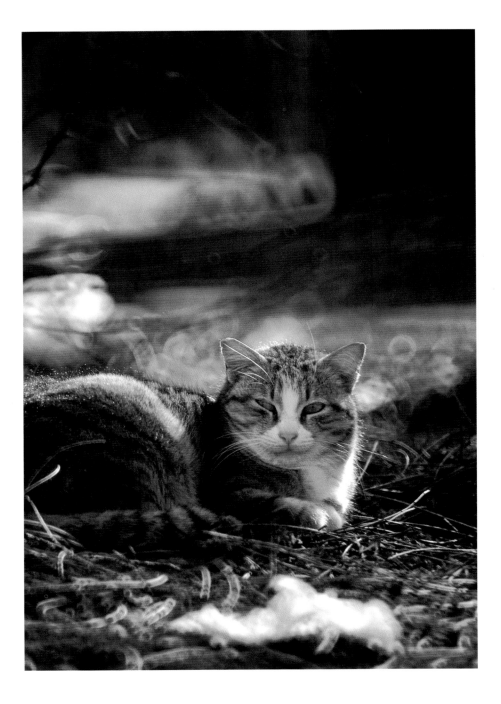

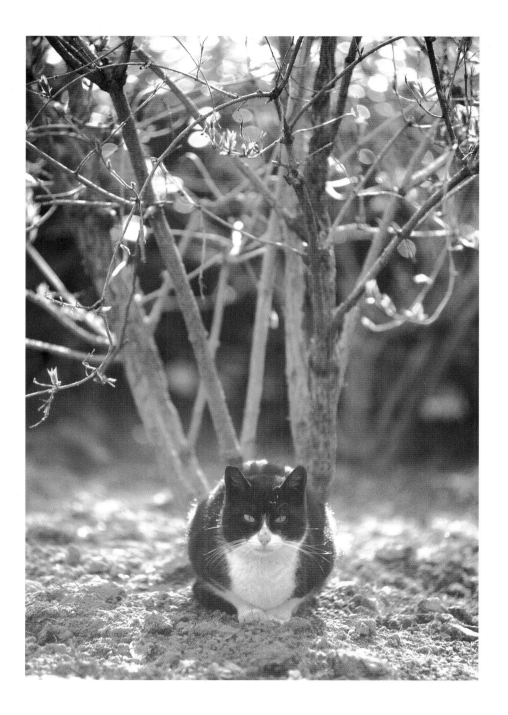

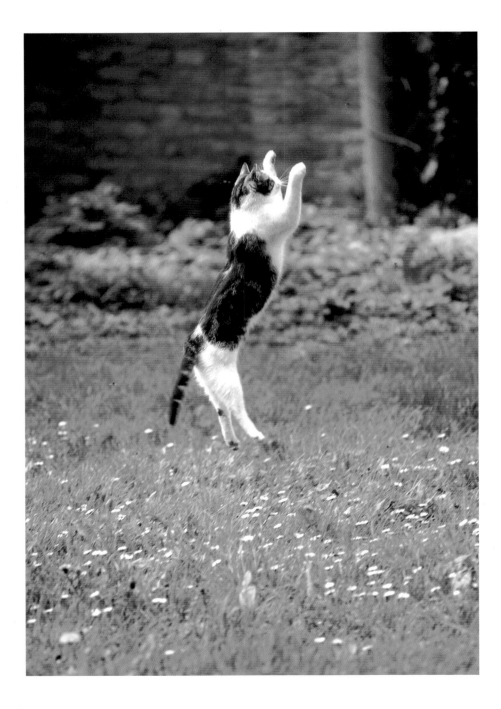

CATS IN A SUNNY SPOT

Time-pressed sightseers don't often visit the eastern section of Venice's main island. A spacious green park extends throughout the area, filled with seniors chatting and enjoying the warmth of the sun, with neighbors strolling while exercising their dogs, with joggers, and with children at lunchtime.

I grocery shopped with the local folks and, occasionally, I ate lunch in the plaza, sitting on a bench and taking in the sunshine. It was here that I saw some cats cautiously poking their faces out from the bushes. Curious to investigate the food they smelled, they slowly approached me. When I shared a little of my food with them, they gobbled it up, all caution abandoned. But once they were finished, they nonchalantly disappeared once again into the bushes.

Except at mealtimes, the cats didn't seem at all interested in human beings. They seemed completely independent, living as they pleased. I remember one cat in particular that was leaping at the bugs darting through the air around him. Innocent and enthusiastic, he inspired me to be more carefree in my own life. Mesmerized by the cat's calm, I thought and dozed in the afternoon sunlight while the cat napped near a vine-entangled wall.

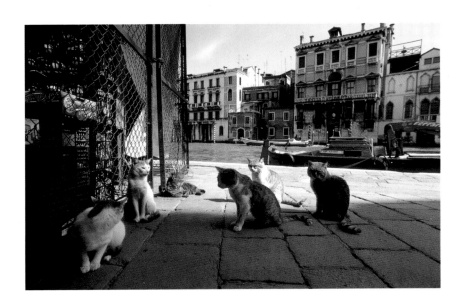

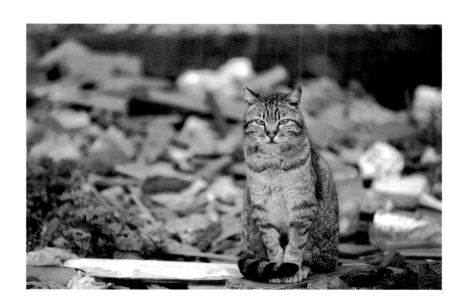

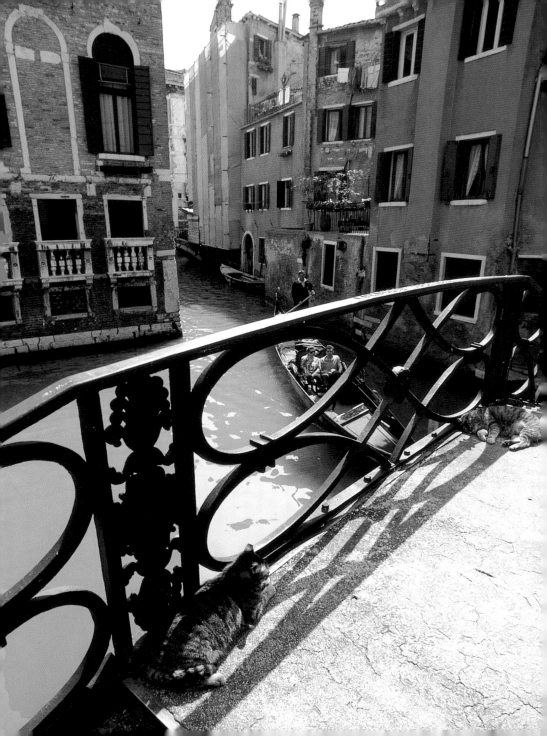

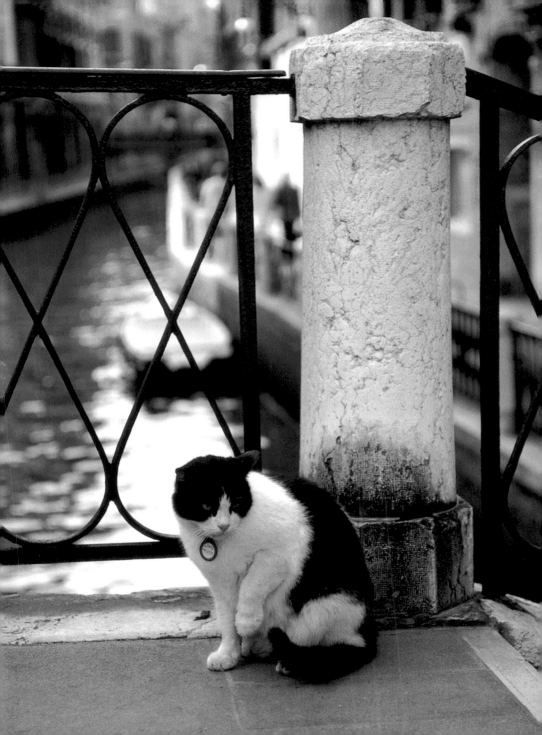

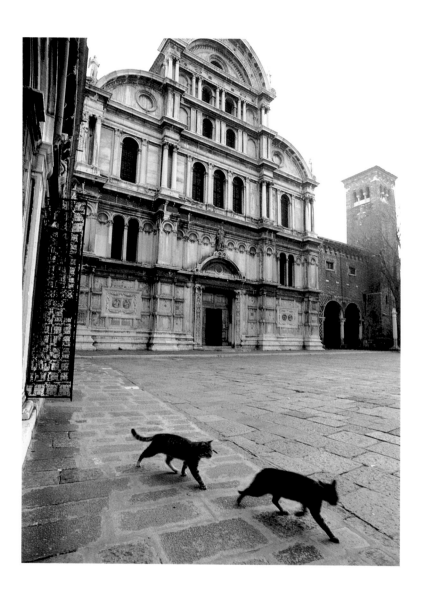

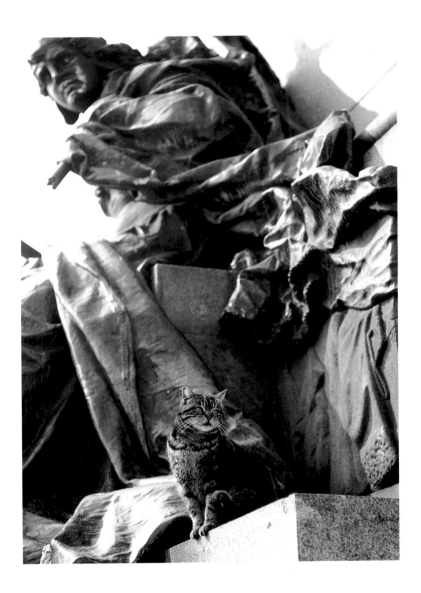

Comune di Venezia - Assessorato alla Cultura
Consiglio di Quartiere - S. Marco - Castello - Sant'Elena

"Aspetti di vita politica ed economica "Aspetti
al tempo della Serenissima" al t

Ciclo di conferenze-dibattito all'Ateneo Veneto

in collaborazione con:
Civici Musei Veneziani di Arte e di Storia
Sopraintendenza ai Beni Artistici e Storici di Venezia
Comando Marina Militare di Venezia
Ente per la Conservazione della Gondola
Quirino dei Brazolo - materiale audiovisivo
Responsabile Manifestazione: Roberto Leprotti
Presidente Consiglio di Quartiere: F. Sanello Moro

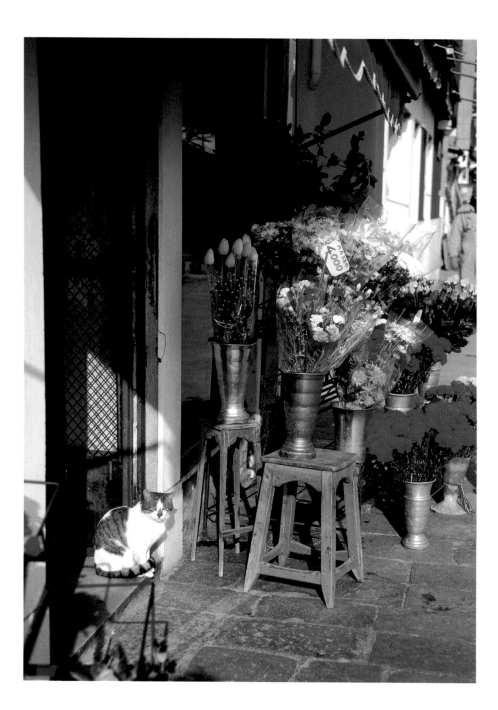

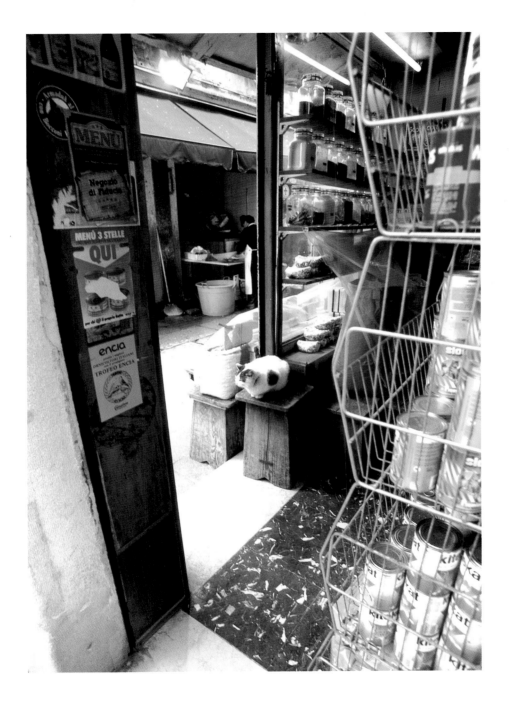

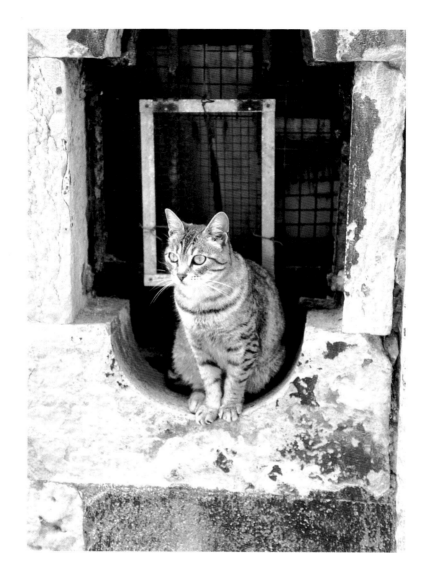

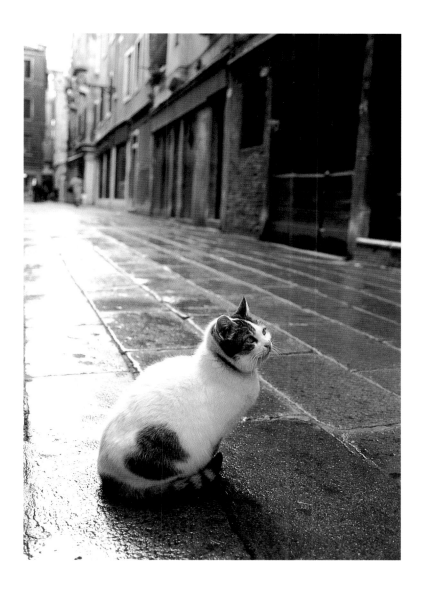

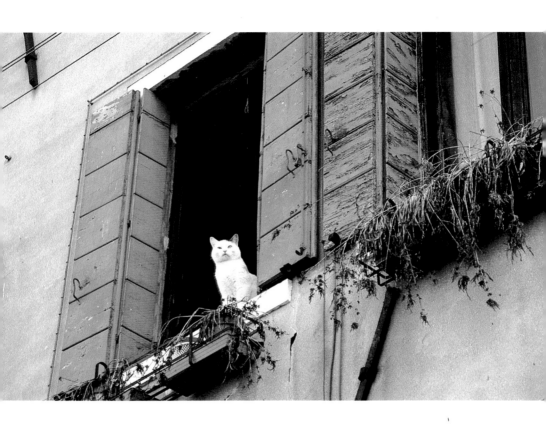

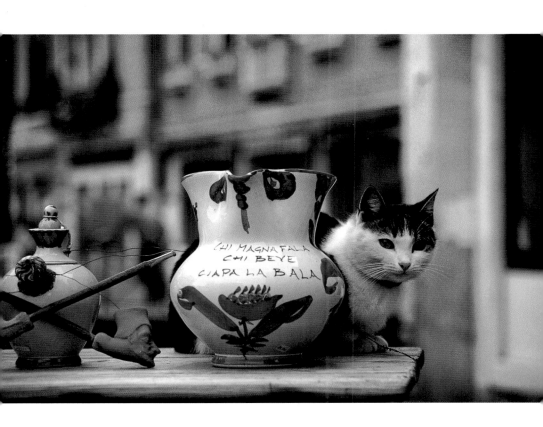

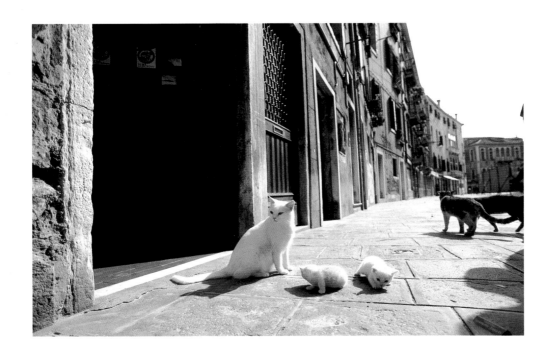

A HOME FOR STRAY CATS

As you stroll the back alleys of Venice, you wander through narrow passages, running endlessly like a labyrinth. The ground floors of the buildings often lack any sign of human habitation. The walls are decayed, the iron gratings over the windows loose and rusted. Even so, the brass bells by the doorways are wonderfully polished, and the upper floors are often festooned with clean laundry fluttering in the breeze, while lively music pours from windows.

These quiet neighborhoods are home to many cats. While conducting their lives behind the protective walls, Venetians still find time to care for the cats. My first friend in Venice, Luigina, had created a place known as "The Home for Stray Cats." In a small rented warehouse, she took in strays. She told me that she had spent ten years preparing meals and helping cats that had collapsed on the streets.

Normally, a place such as this might be viewed with distaste by its neighbors, but here, in contrast, it receives good-hearted support from many people. In our tour of her "home," Luigina happily introduced me to two toddling kittens, carefully watched by their mother, and said to me, "They are the first kittens born in my home." She was content with her cats, which were visited by countless neighbors dropping by to see the kittens playing in the mild spring sunshine.

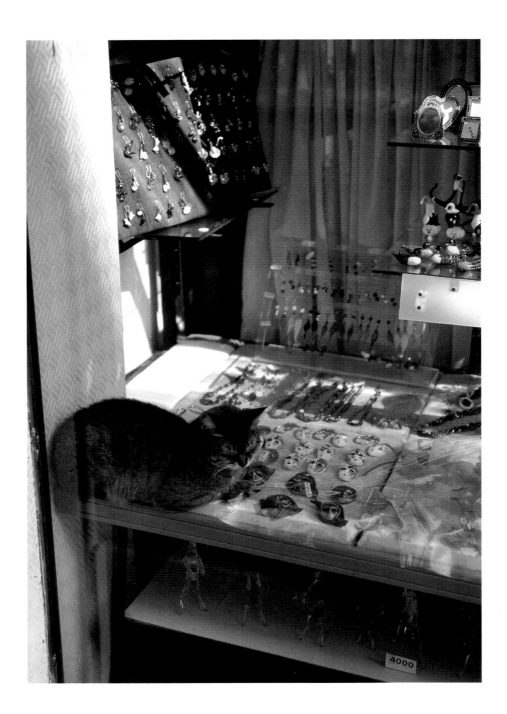

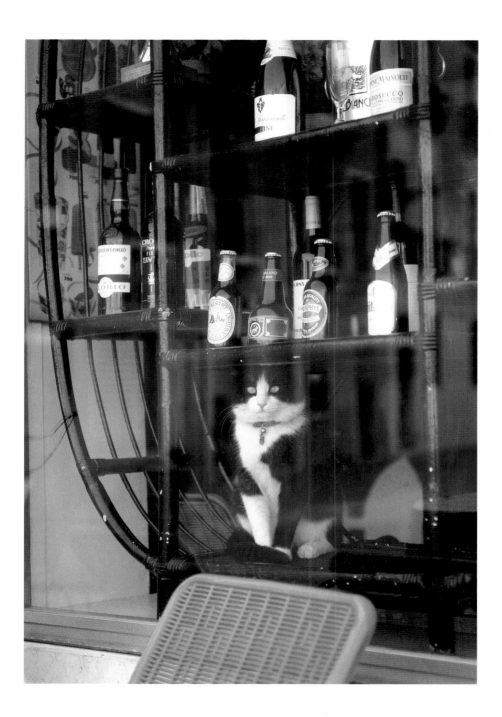

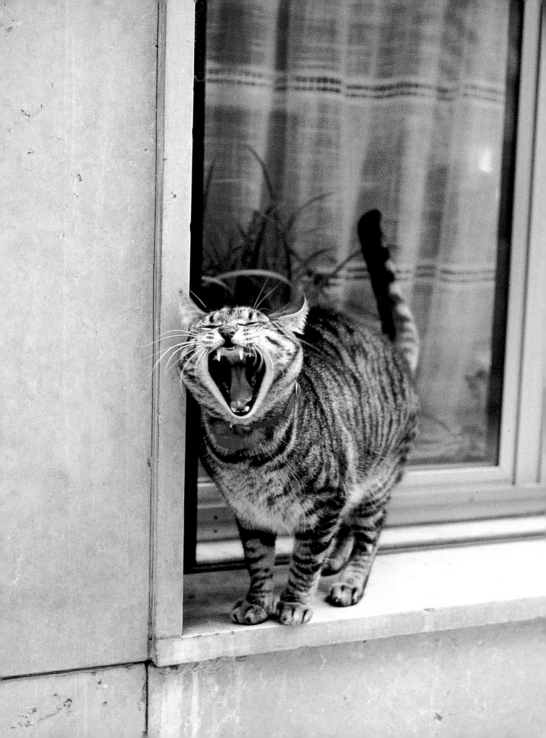

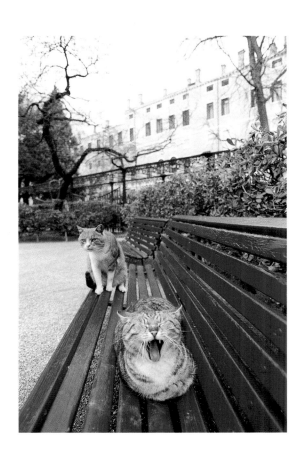

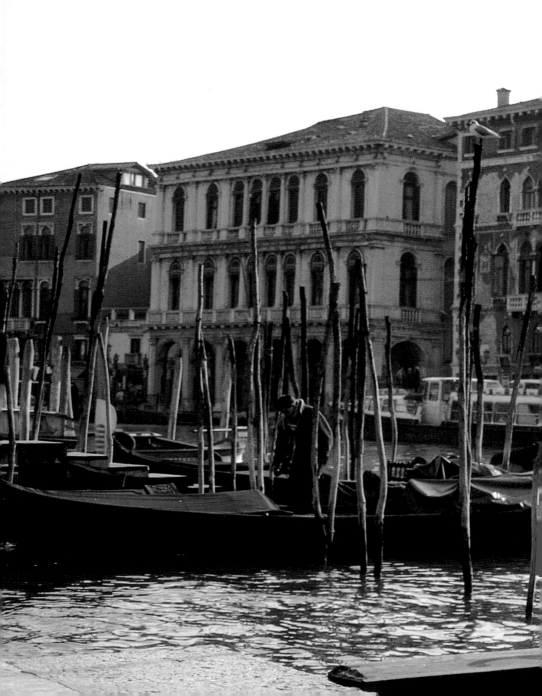

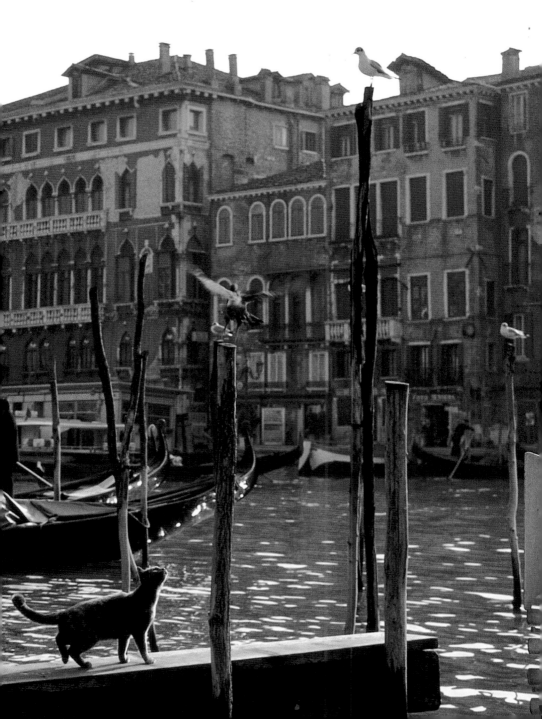

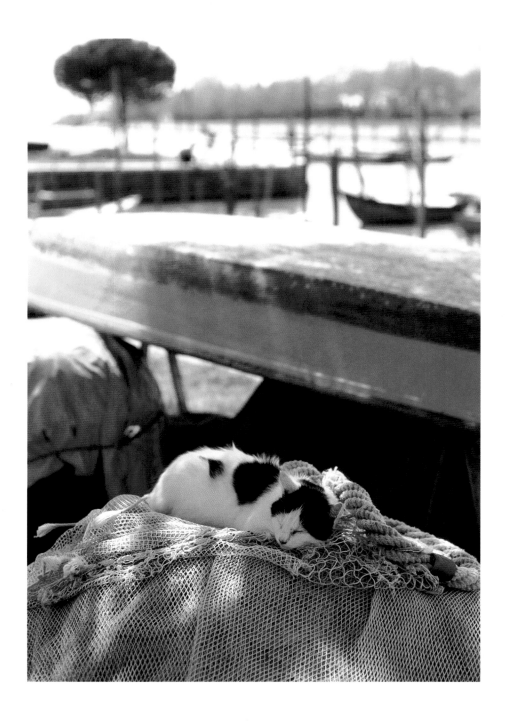

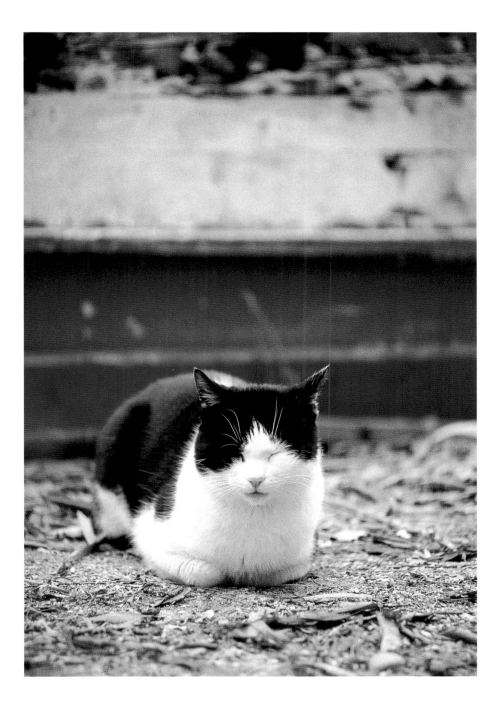

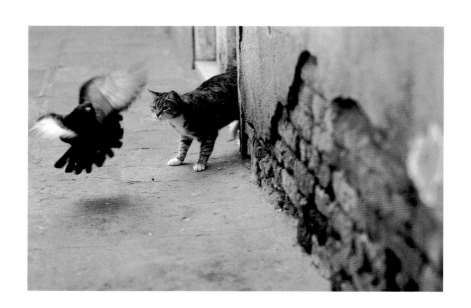

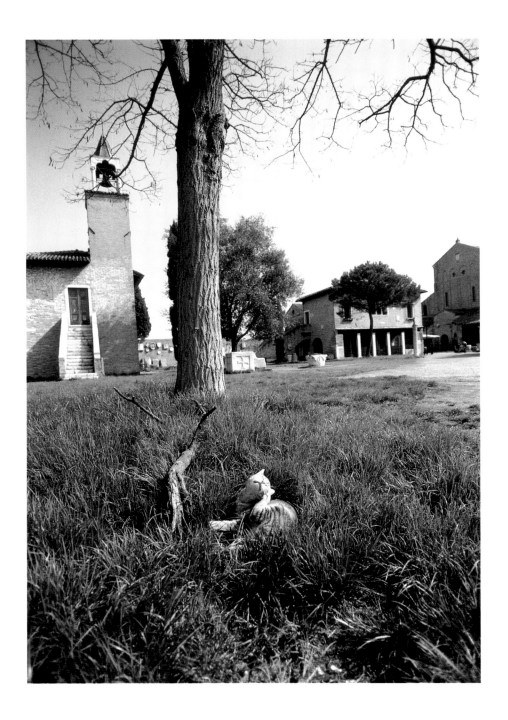

I eventually grew tired of walking on the main island, so I decided to visit nearby islands using the regular boat service. On a one-hour ride to Torcello Island, we passed by Buranu Island with its colorful houses standing side by side.

At Torcello, we disembarked and were led from a narrow walkway to a canal that flowed by two churches at the island's center. In the distance I heard cowbells.

I looked around for the source of the sound, but I could see no cows and no bells. Then, I noticed that a woman who had been on the boat was carrying a bell and ringing it methodically. She accompanied the clanging bell with shouted bits of song. Until we reached a small plaza, she continued singing and clanging. Suddenly, in the center of the plaza, a pack of stray cats appeared.

At the cats' arrival, the woman stopped singing and, working with a friend, offered food to the cats. After satisfying the large group, she again took up the bell, appealing to other strays to come to dinner and not to miss their meal. At noon, the bells of the church joined those of the woman, tolling for noon and for the joy that the woman found in feeding her cats. As the bells peeled across the island, I too experienced a sense of happiness and well-being, knowing that there were people with the goodness to care for strays.

On the boat ride back, I thought about the cats and the mysterious bells. I felt as if both the cats and I were granted some release by the sound of the bells.

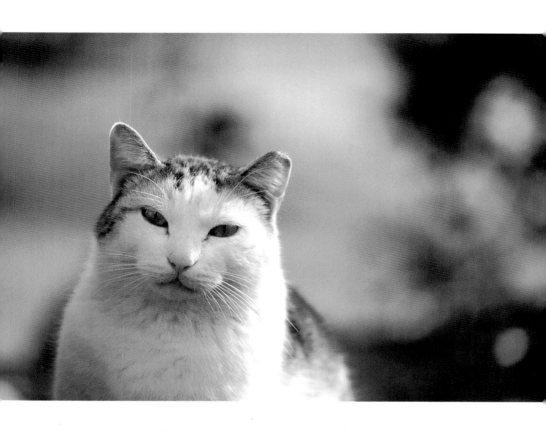

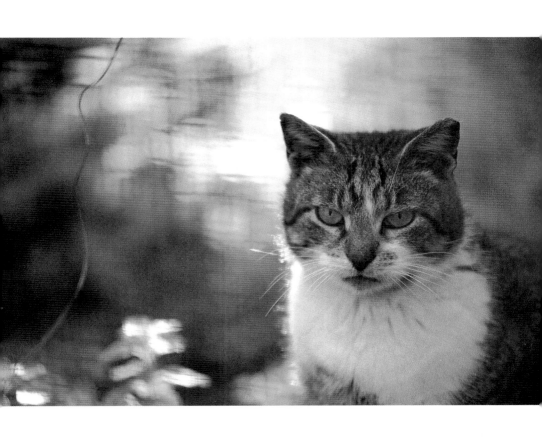

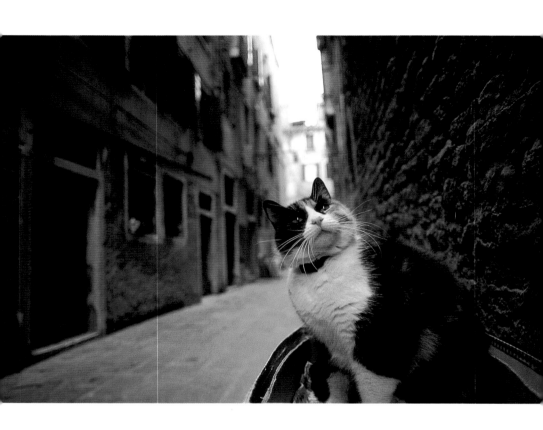

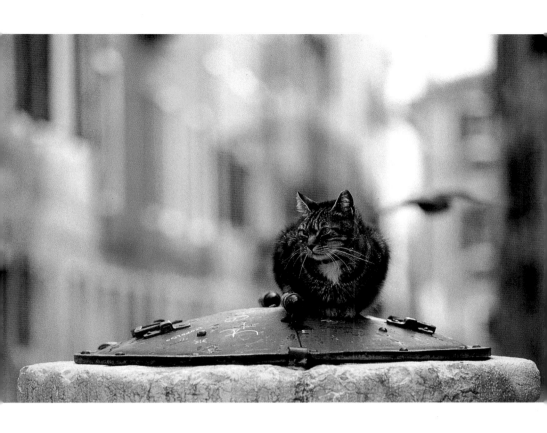

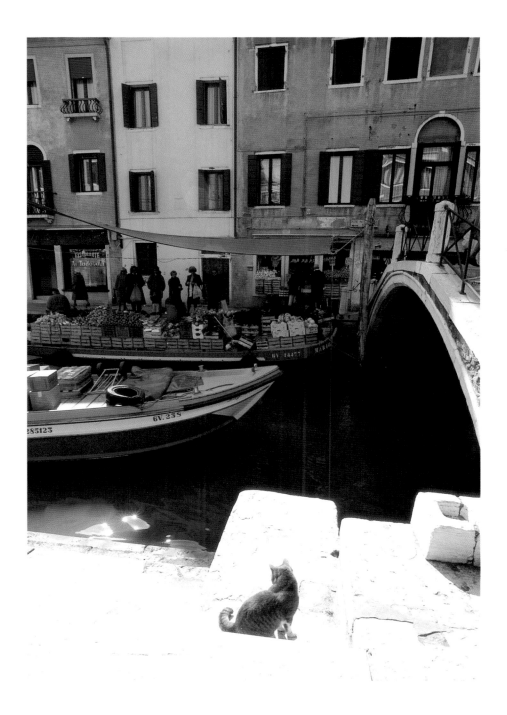

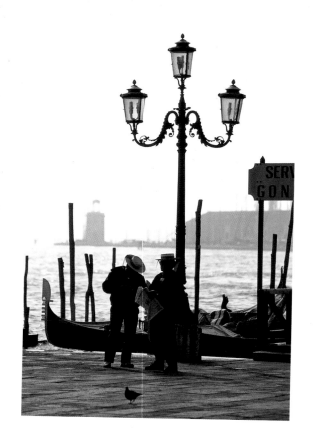

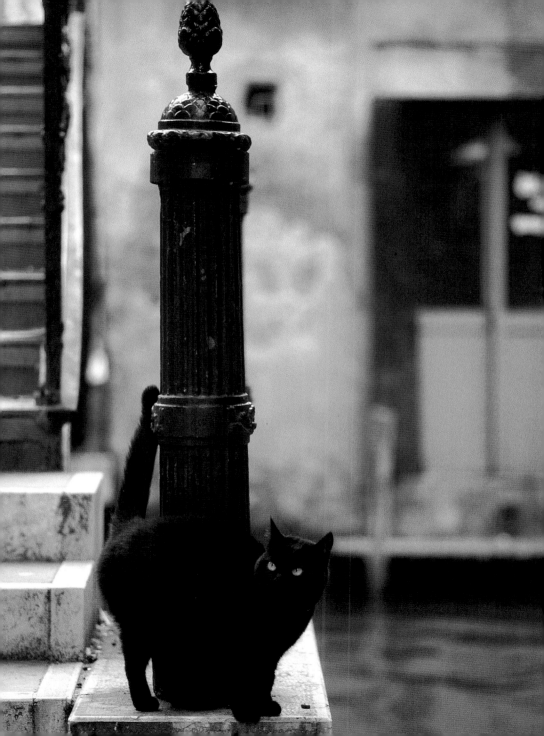

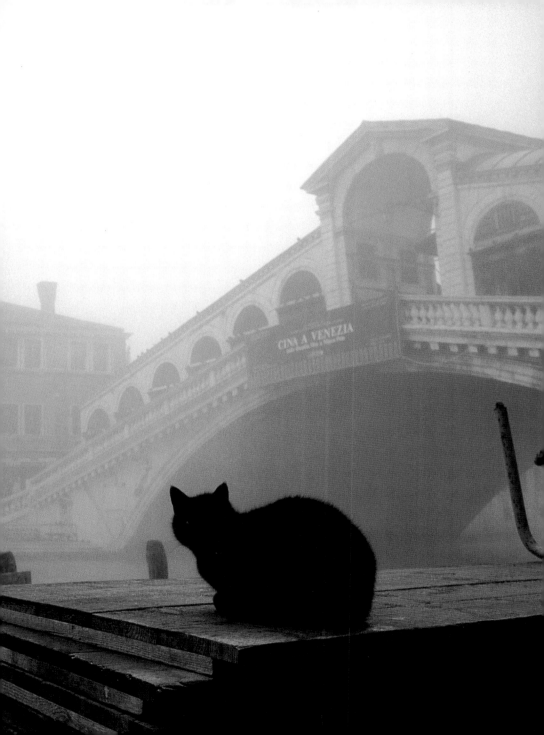

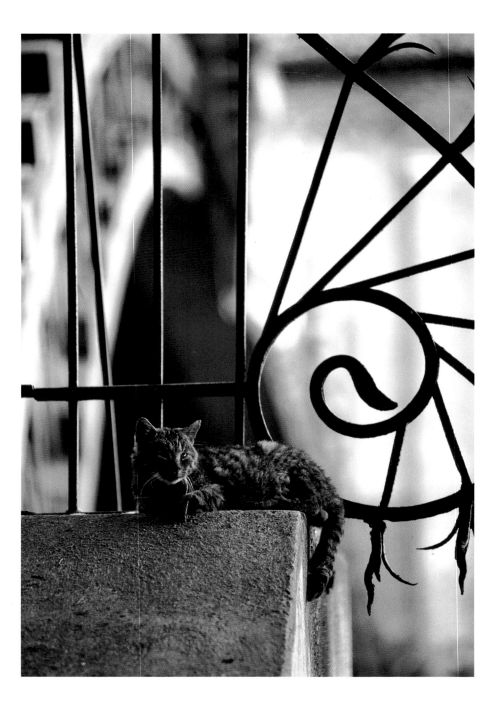

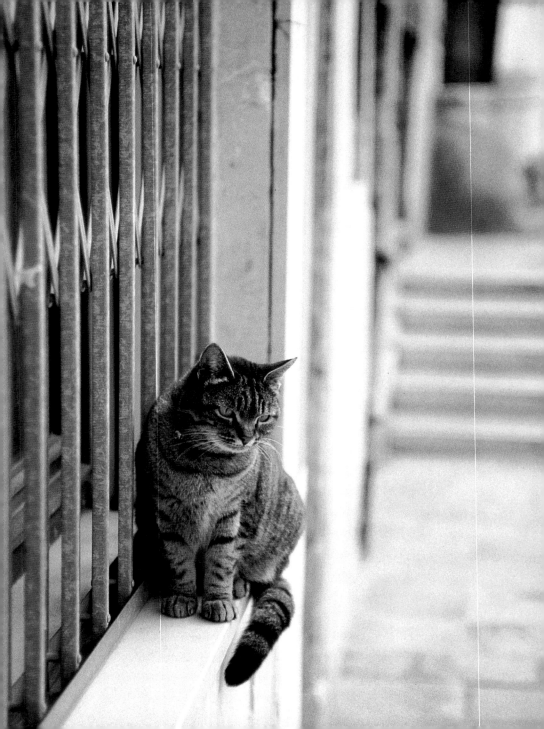

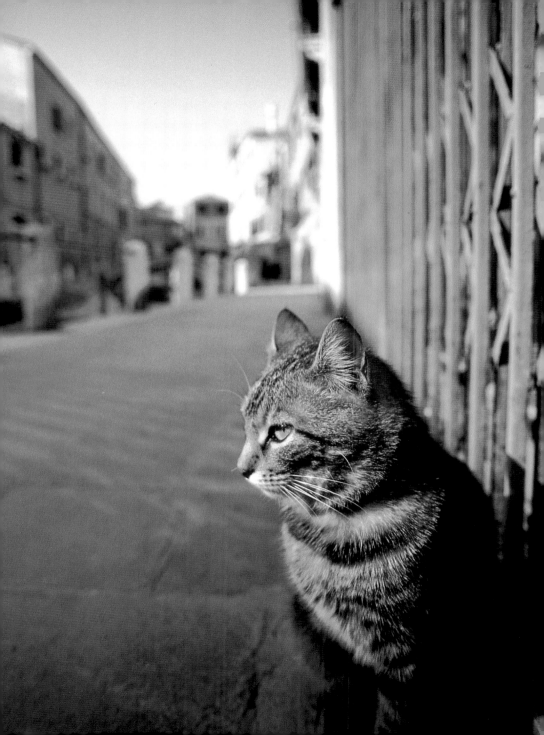

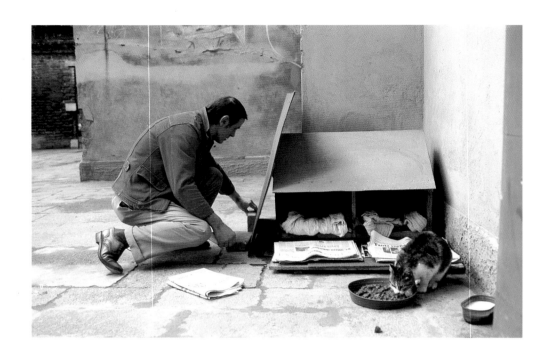

THE CATS' SCHOOL LUNCH

Venice regains its natural rhythms in the winter, when the sight-seers have departed and the residents can move throughout their city unhindered by tourists. In the spring, I abandoned the well-trodden paths and was able to sense the quiet life of the local people.

One afternoon I came upon a woman feeding stray cats in a park. When I approached and took her picture, she became visibly upset. I tried to get her approval, but she would not say anything. To avoid upsetting her, I joined a child who was watching as the woman fed her cats.

Each cat received a portion of the meal: ground meat mixed with pasta. When the cats finished, she cleaned up and handed dry food to the cats that still looked unsatisfied. As I left, I said good-bye and she finally smiled.

Another morning, I ran into a man feeding stray cats in a plaza next to a canal. In my poor Italian, I asked permission to snap some photos. He grudgingly said okay, but seemed suspicious: why would this strange tourist want to take his picture. I, of course, could not converse with him in Italian, but I wanted to photograph him feeding the cats. I did not see him again even though I returned to the same plaza a few days later.

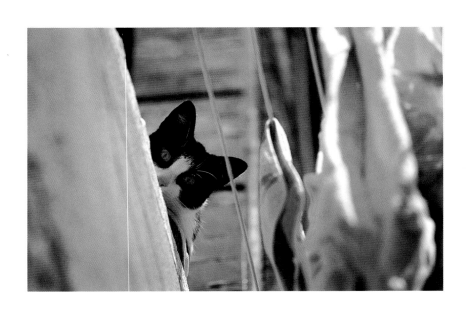

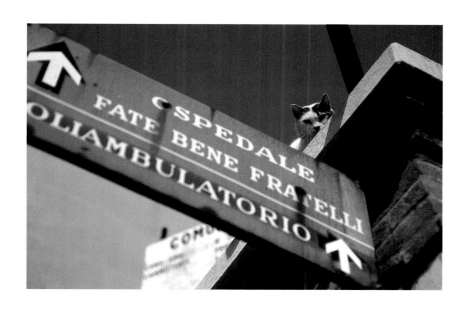

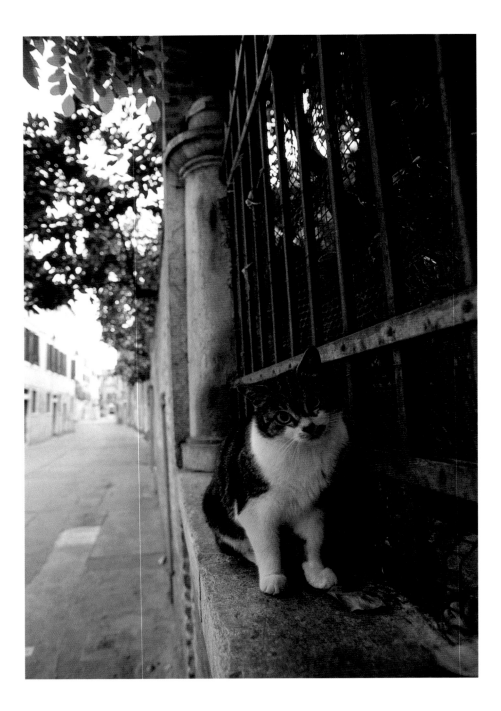

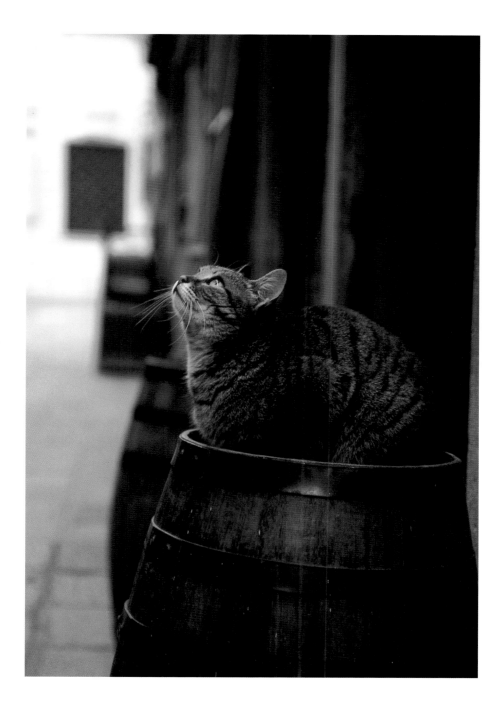

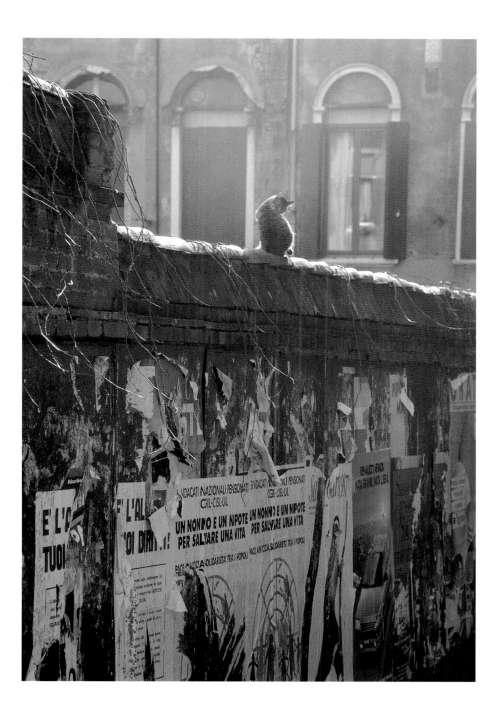

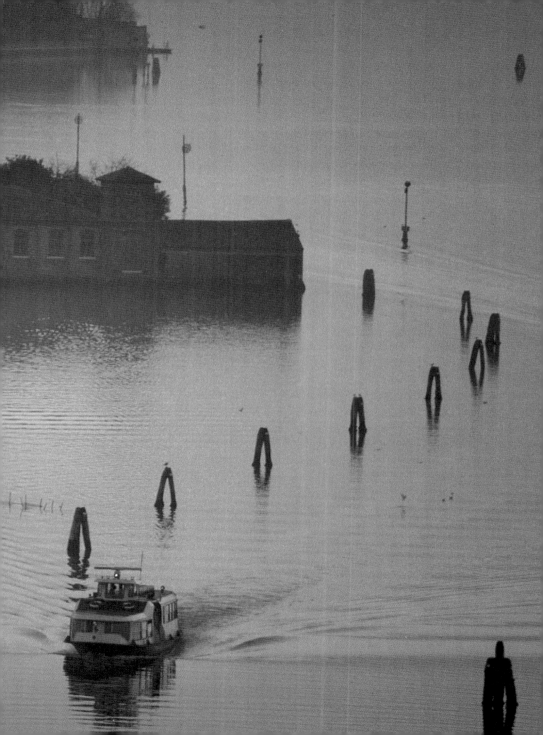

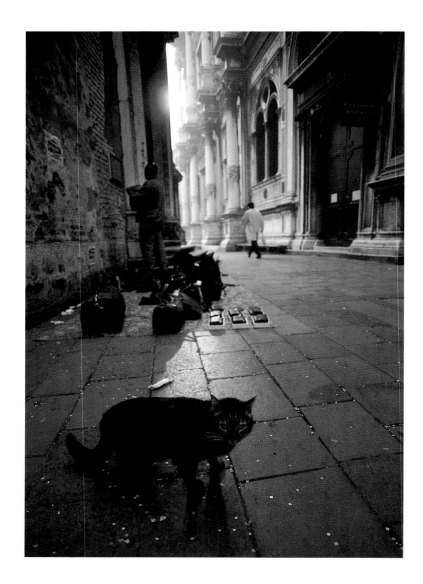

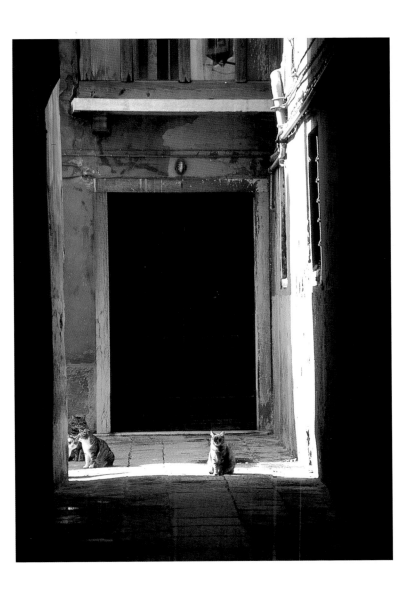

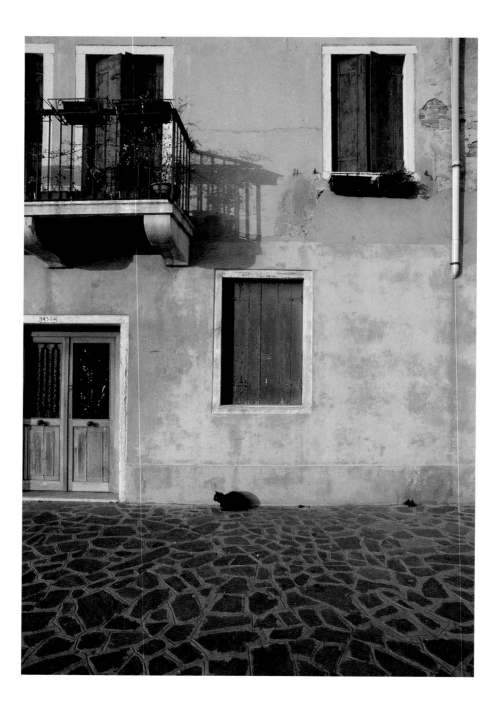

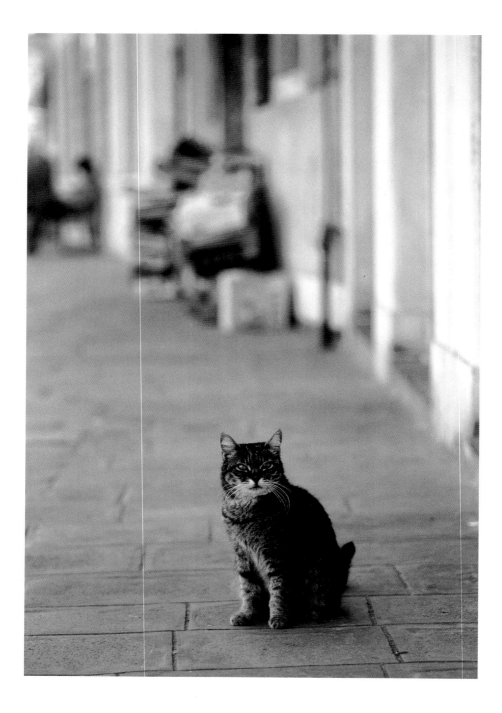